The Staffordshire Hoard

Kevin Leahy and Roger Bland

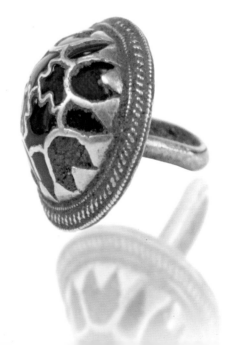

THE BRITISH MUSEUM PRESS

£1 from the sale of every book will go to the Staffordshire Hoard appeal
fund. You can also donate online at www.bmag.org.uk/support-us.
Your donation will support the efforts by Birmingham Museums and
Art Gallery and the Potteries Museum & Art Gallery, Stoke-on-Trent, to
acquire the hoard, in partnership with the councils of Lichfield District,
Staffordshire County and Tamworth Borough. In the event that the
attempt to acquire the hoard is unsuccessful, your donation will be
used to support a related programme of research, conservation,
interpretation, display and education.

First published in 2009 by
The British Museum Press
A division of The British Museum Company Ltd
38 Russell Square, London WC1B 3QQ
www.britishmuseum.org

A catalogue record for this book is available from the British Library

ISBN 978-0-7141-2328-8

Designed by Price Watkins
Printed in Singapore by SC (Sang Choy) International Pte Ltd.

Extracts from *Beowulf: A Verse Translation* by Seamus Heaney,
Faber and Faber Ltd

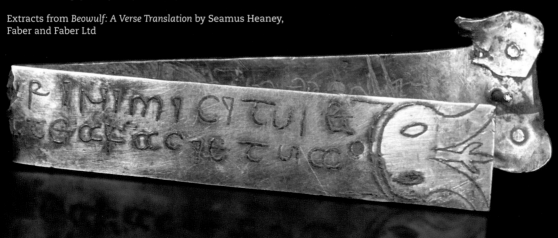

Contents

Acknowledgements

THERE has been an enormous effort on the part of many individuals and organizations to take the Staffordshire Hoard to this stage in such a short space of time. We would like to thank first of all Terry Herbert, not only for reporting the find but also for his subsequent assistance in the excavation, and also Fred Johnson, the owner of the land where the hoard was found, for his generous cooperation in allowing an excavation to take place on his property. Duncan Slarke, Finds Liaison Officer, played an essential role in coordinating the initial response to the discovery and in liaising between Terry Herbert, Fred Johnson and the archaeologists and in sorting out the finds.

Stephen Dean and Ian Wykes of Staffordshire County Council's Historic Environment team supervised the archaeological investigation of the findspot, which was undertaken by a team from Birmingham Archaeology under Alex Jones and Bob Burrows. Funding for this was received from English Heritage, whose contacts were Bill Klemperer, Inspector of Ancient Monuments, and Barney Sloane, Head of the Historic Environment Commissions.

We are extremely grateful to the coroner for South Staffordshire, Mr Andrew Haigh, for the helpful and cooperative way in which he conducted his enquiry into the find.

The communications teams of the organizations involved worked hard on the announcement of the find and subsequently, especially Richard Caddy

and Clare Hardie of Staffordshire County Council, Carmel Girling and Geoff Coleman of Birmingham City Council and Andrew Brunt of Stoke-on-Trent City Council. Our thanks go to Dave Rowan of Birmingham Museums and Art Gallery, Daniel Buxton and Duncan Slarke for photographing the objects.

The curatorial and conservation staff of Birmingham and Stoke museums were also much involved in working on the finds and putting them on temporary display, especially Deborah Cane, Simon Cane, Rita McLean, David Symons, Jane Thompson-Webb and Phil Watson of Birmingham Museums and Art Gallery, and Keith Bloor and Deb Klemperer of the Potteries Museum & Art Gallery, Stoke-on-Trent. From the British Museum, Caroline Barton, Hannah Boulton, Olivia Buck, Sara Carroll, Paul Goodhead, Michael Lewis, Caroline Lyons, Sonja Marzinzik, Sonia d'Orsi, Janina Parol, Dan Pett, Ian Richardson, Carolyn Marsden Smith, Gareth Williams and Jonathan Williams all contributed to the project, as did Helen Geake, National Finds Adviser in the Portable Antiquities Scheme.

We are also extremely grateful to those scholars in other institutions who commented on the finds before the inquest, especially Leslie Webster, formerly of the British Museum, Elisabeth Okasha of the University of Cork and Michelle Brown of the University of London.

Lastly, we would like to thank Charlotte Cade, Coralie Hepburn and Ray Watkins, who worked wonders to produce this book in a very short time.

The story of the find

THE first objects from the hoard were discovered by Terry Herbert on 5 July 2009, while using a metal detector on farmland near Lichfield in Staffordshire. Over the next five days he unearthed more gold objects, all in the plough soil – 244 bags in all – which he reported to Duncan Slarke, then Finds Liaison Officer for Staffordshire and the West Midlands in the Portable Antiquities Scheme (PAS; see p.45).

Terry Herbert had been a metal-detector user for some fifteen years; he was a member of his local metal-detecting club and he had voluntarily reported finds to the Finds Liaison Officer over the last six years. Most importantly, he was detecting with the written permission of the landowner.

Duncan Slarke contacted Roger Bland, Head of the PAS, Kevin Leahy, National Finds Adviser, Ian Wykes and Stephen Dean from Staffordshire County Council's Historic Environment team and Birmingham and Stoke museums. The first priority was to recover archaeologically the rest of the hoard without delay, since the findspot was in a very vulnerable place. It was very fortunate that the archaeologists from Staffordshire County Council were able to attend the site the next day and that English Heritage quickly agreed to fund an excavation.

Birmingham Archaeology was commissioned to carry out the excavation, which was completed within a month, with Terry Herbert involved throughout. The hoard had been scattered by the plough and an area of 9 x 13 metres was excavated. A geophysical survey of the field where the find was made was undertaken and this revealed a feature which could be a ditch close to the findspot

On the soil where the plough had left it, a magnificent piece of Anglo-Saxon garnet work. The objects had suffered little damage, suggesting that they had only recently been lifted by the plough.

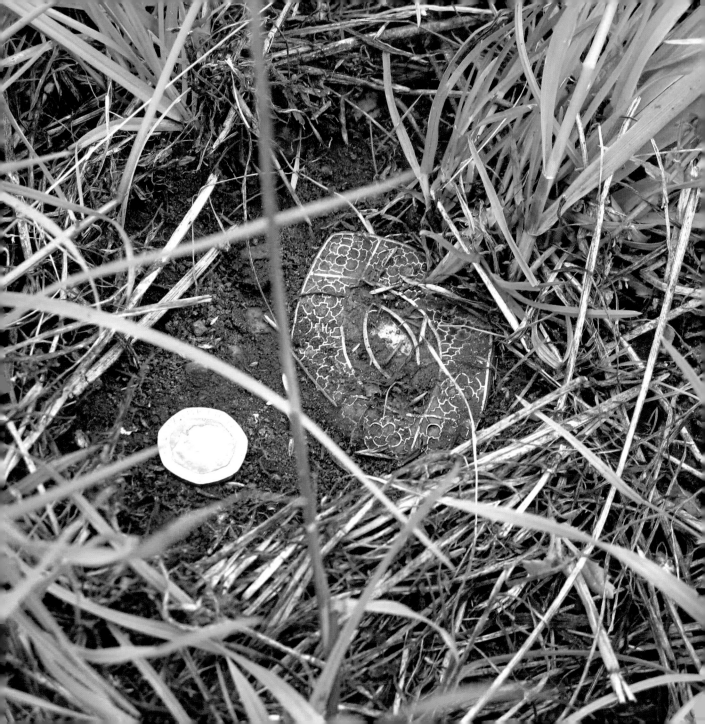

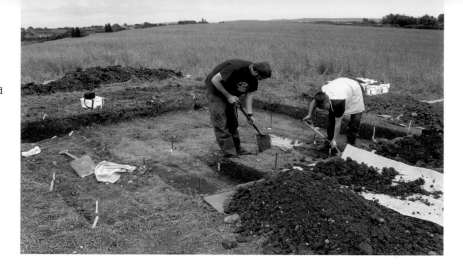

The findspot was excavated by hand and the soils spread for further checking with a metal detector.

and abutting the field boundary. The small section of ditch that was excavated produced no evidence for dating and it is planned to examine this further.

The excavation recovered a total of 1662 objects from the hoard (this number includes the items contained in fifty-six blocks of soil, which were only unpicked by Birmingham Museum after the initial announcement), but it is impossible to say anything about the container in which the hoard must have been placed. A final geophysical survey undertaken by a team from the Home Office did not reveal any further objects and it is believed that the whole of the hoard has been recovered. Dr Leahy and his wife wrote an initial catalogue of the hoard, which was then sent to the coroner for South Staffordshire, Mr Andrew Haigh, who declared the hoard to be Treasure at an inquest on 24 September 2009.

Meanwhile Dan Pett, ICT Adviser to PAS, had built a website for the hoard, www.staffordshirehoard.org.uk. This contained all the information available, together with 650 images, and received over 10 million hits in the first week it went live.

All this work had been done extremely rapidly, the interval between first discovery and the announcement following the inquest being less than twelve weeks.

The announcement of the hoard in Birmingham Museum & Art Gallery on 24 September attracted extraordinary attention both in this country and

around the world, and the decision to break with precedent and to put a selection of the finds on temporary display at the museum was hugely successful. Over 40,000 people saw the exhibit, queuing for several hours to do so, while the museum extended its opening hours in order to accommodate the huge public interest in the hoard.

This find is unique. No hoard of gold and silver objects from this period has ever been found before. All the previous notable discoveries have been grave burials, such as those from Sutton Hoo in Suffolk and Prittlewell in Essex, or single, unassociated, finds. The hoard contains some 712 objects made of gold, 707 of silver, 73 of copper alloy and 93 of other materials.

The hoard is most unusual, not least because it largely comprises 'war-gear' and there are no items of female adornment. There are many fittings from the hilts of swords, including 86 pommel caps from swords or seaxes (short single-edged swords or knives) and 135 sword hilt plate fragments. There are also fragments of at least one helmet; four, possibly five, Christian crosses; and many more objects which have yet to be identified.

The hoard's importance is summed up by Leslie Webster, formerly Keeper of the Department of Prehistory & Europe at the British Museum:

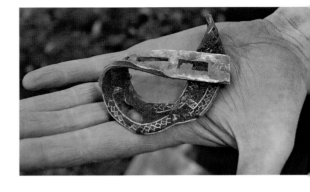

Set with garnets but still covered in earth, a gold strip emerges after 1300 years.

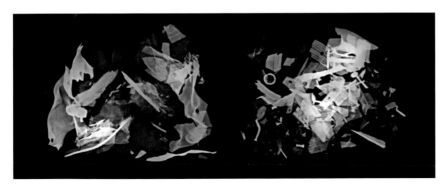

X-rays of the earth blocks showed them to be full of gold and silver fragments.

'This is going to alter our perceptions of Anglo-Saxon England in the seventh and early eighth centuries as radically, if not more so, as the 1939 Sutton Hoo discoveries did; it will make historians and literary scholars review what their sources tell us, and archaeologists and art-historians rethink the chronology of metalwork and manuscripts; and it will make us all think again about rising (and failing) kingdoms and the expression of regional identities in this period, the complicated transition from paganism to Christianity, the conduct of battle and the nature of fine metalwork production – to name only a few of the many huge issues it raises. Absolutely the metalwork equivalent of finding a new Lindisfarne Gospels or Book of Kells.'

Date of the deposit

The date of the deposit, the reason why it was buried and who might have buried it have caused great puzzlement and speculation amongst scholars. At the time of writing, just four months after the discovery of the hoard, we cannot do more than outline some of the different views that have been expressed.

Attention has been focused on identifying and dating the latest object, since the hoard can only have been buried at some time after it was made. However, most of the objects cannot be dated except in a general way and the unprecedented number of certain items, such as sword fittings, could well mean that we have to revise existing chronologies for them. The inscribed object (see p.38) has been variously dated from the seventh to the ninth centuries, which is a very broad span.

There are a few fixed points that enable us to date the types of objects in the hoard; one of those is the Sutton Hoo deposit, which is currently believed to have been buried in the early seventh century (see p.18). The hoard's sword fittings and some of the studs bear similarities to those excavated at Sutton Hoo.

The German scholar Bernhard Salin, in a book published in 1904, divided the animal ornament seen on many metal objects

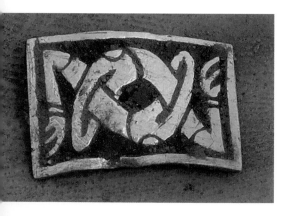

Small gold plate decorated with two animals, each with a single leg and its paper-clip-like jaws around the other's neck.

of this period into two styles: Style I, characterized by animals which are disjointed, with the head and limbs being arranged within the field; and Style II, characterized by animals with interlaced bodies and distinctive jaws and eye settings. The Staffordshire Hoard contains no examples of Style I, current in England in the fifth and sixth centuries, but at least twenty-seven objects are decorated in Style II, characteristic of the late sixth and seventh centuries. Some objects show signs of wear and the oldest may therefore date to the late sixth century.

As regards the most recent object in the hoard, at present expert opinion is divided between those who believe that no item can certainly be dated to after 650 and those who suggest that there are objects (such as some of the sword pyramids) which should be dated to the late seventh century. Analysis of the metal content of the objects may throw light on this question. There is also the possibility that some of the fragments of wood in the hoard can be carbon-dated. So the most that can be said at present is that the hoard is likely to have been buried at some time between about 650 and 700.

Purpose of the deposit

The discovery of the deposit in Staffordshire should cause no surprise as this was the heartland of the Anglo-Saxon kingdom of Mercia, which was militarily aggressive and expansionist during the seventh and eighth centuries (see p.14). The hoard's martial items could have been collected by kings Penda, Wulfhere or Aethelred during their wars with Northumbria and East Anglia, or indeed by someone whose name is lost to history.

However, the purpose of the deposit is uncertain, and interpretation is made more difficult by the complete absence of comparable finds from either England or the Continent. It is notably 'unbalanced', consisting in the main of fittings from swords; other related pieces, including baldric fittings and large triangular buckles, are missing, as indeed are feminine objects, such as dress fittings, pendants and brooches. There is at least one helmet present, and there may be others, but further work is needed to reconstruct the fragments.

It has been suggested that this is a 'trophy hoard' – material collected from vanquished enemies, the sword blades perhaps re-used but stripped of their valuable fittings. If this is so, it could either represent the spoils of a single battle, or be the product of a long military career.

This mass of material is unlikely to have come from a grave as the objects that we might expect to see in a burial of this period are absent, nor is there any trace of a grave or mound. It could, however, be some kind of ritual deposit; the Portable Antiquities Scheme has, over the last ten years, recorded nine pommels and other sword fittings, possibly stripped from their blades and apparently abandoned. The hoard might represent a similar practice, but on a much larger scale.

Hoards of coins and other precious-metal objects are generally assumed to have been buried by their owners at a time when they perceived they were being threatened. It is only those hoards whose owners were unable to return to recover them that remain to be discovered today. Caches of silver coins and silver objects dating to the tenth century are associated with Viking incursions, but otherwise hoards from the Anglo-Saxon period only consist of coins, and these are rare before the late seventh century. Perhaps the best example is the hoard of ninety-nine gold coins from Crondall in Hampshire, thought to have been buried around 645. The Sutton Hoo burial included thirty-seven gold coins known as *tremisses*, made by the Merovingian kings of France, and three blanks. However, there were no coins in the Staffordshire Hoard, although gold coins made both on the Continent and in Britain were in circulation at this time.

The hoard was deposited on high ground and at present no context for it is known. Further archaeological research on the findspot is needed.

It is also possible that the hoard represents a royal treasury. Nicholas Brooks of the University of Birmingham has noted that Anglo-Saxon nobles paid 'heriot' in the form of weapons and bullion to the king when they died, and in return the king would honour a vassal's wishes about the disposal of his property. He argues that kings of this period are likely therefore to have had a supply of weapons which they could give to young warriors joining their service and he has suggested that this hoard could represent such a stock of

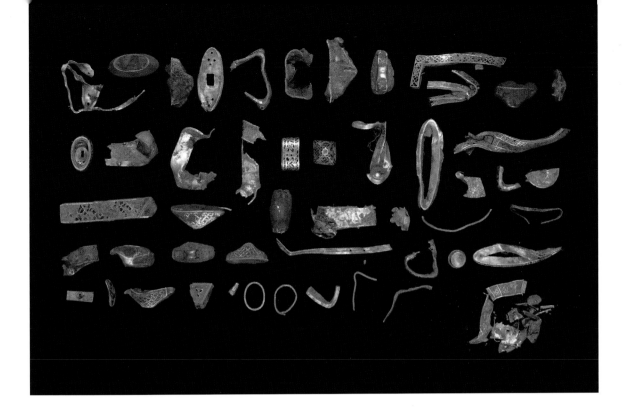

weue (although this theory would not explain the presence of the crosses).

Perhaps the last word on this question should rest with the famous Anglo-Saxon poem *Beowulf*, thought to have been written down in the eighth or early ninth centuries, but reflecting a much earlier oral tradition. Although the passage (lines 3160–5) is referring to the deposition of gold in a king's grave, it could just as well be describing the burial of a hoard like this.

> And they buried torques in the barrow, and jewels
> and a trove of such things as trespassing men
> had once dared to drag from the hoard.
> They let the ground keep that ancestral treasure,
> gold under gravel, gone to earth,
> as useless to men now as it ever was.

If discovered alone, any of these objects would have been considered important; the quality and quantity of finds is stunning.

Anglo-Saxon England

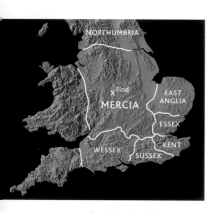

England in the 7th century.

THE Staffordshire Hoard consists mostly of weapons, reflecting the turbulent times in which it was gathered together, perhaps as battlefield trophies during the seventh century. In this period, the Midland kingdom of Mercia was aggressive and expanding rapidly, leading in the eighth century to it controlling much of England under Offa (757–796), a king of European importance. Under kings Penda (633–655), Wulfhere (658–675) and Aethelred (675–704), Mercia was engaged in wars with Northumbria and East Anglia, when this material could have been collected. Why it should have been buried is something that we do not know, and indeed may never know.

The end of Roman Britain is usually taken as being 410, after which towns declined, coins ceased to be in everyday use and society fragmented. From around 450 we start to see increasing evidence for incomers whose life-styles reflected the peoples of northern Germany and Scandinavia from whence they came. Burial practices changed, the dead now being either cremated (generally in the north and east of England) or buried with grave goods (in southern England). Finds from the graves show that women now dressed in a Germanic way and many of the men were buried with weapons. But the descendants of the Romano–British people must have lived along side these 'Anglo-Saxons', and indeed Penda of Mercia found a powerful ally in the Welsh king Cadwallon of Gwynedd.

At first the Anglo-Saxons must have been divided into relatively small groups, but by the seventh century kingdoms were emerging: Mercia in the Midlands, Northumbria to the north of the Humber, the East Angles of Norfolk

Key dates

c.410	Conventional date for the end of Roman Britain.
c.450	Anglo-Saxons arrive in England.
597	St Augustine's mission to England.
c.595–c.640	Sutton-Hoo ship burial.
616	Battle on the River Idle, Yorkshire: Edwin, supported by Raedwald of East Anglia, defeats Aethelfrith and becomes king of Northumbria.
627	St Paulinus' mission to Northumbria.
632	Battle of Hatfield: Edwin defeated and killed by Cadwallon of Gwynedd and Penda of Mercia.
633	Battle of Rowley Burn (Hexham): Cadwallon defeated and killed by Oswald who becomes king of Northumbria.
641	Battle of 'Maserfelth' (Oswestry?): Oswald defeated and killed by Penda.
655	Battle of 'Winwaed' (Leeds area?): Oswiu of Northumbria defeats and kills Penda of Mercia.
657	Wulfhere's revolt puts an end to the Northumbrian control of Mercia, of which he becomes king.
664	Synod of Whitby chooses Roman, not Celtic, Christianity.
674	Wulfhere invades Northumbria and is defeated by Ecgfrith (Oswiu's son).
669	St Chad, Bishop of Mercia, establishes the Cathedral at Lichfield (probably already a sacred site).
679	Battle of the Trent: Aethelred of Mercia defeats Ecgfrith, removing the threat from the north.
685	Battle of Nechtanesmere (Forfar): Ecgfrith defeated and killed by the Picts.
716	Aethelbald becomes king of Mercia and achieves power over other Anglo-Saxon kingdoms.
731	Bede completed his 'Ecclesiastical History of the English People', our primary record of this period (see p.17).
757	Aethelbald murdered by his body-guard at Seckington, near Tamworth. Offa becomes king of Mercia.
796	Death of Offa of Mercia, a king of European stature who built 'Offa's dyke' a 120-mile long fortification separating England from Wales. The Mercian king's chief centre was at Tamworth, not far from the spot where the hoard was found.
835	First recorded Viking raid.
879	A large part of Mercia was taken over by the Vikings, forming part of the 'Danelaw'.
911–918	Mercia ruled by Aethelfaed 'The Lady of Mercians'. Sister of King Alfred, she was married to Aethedred of Mercia and, following his death, ran both Mercia and highly successful campaigns against the Vikings, reconquering much of the Danelaw.
918	Death of Aethelfaed at Tamworth. Succeeded by her daughter, Ælfwynn (unlike other Germanic peoples the Mercians seemed happy to accept female rule). In the face of a difficult military situation Ælfwynn was deposed by her uncle, Edward the Elder, and the kingdoms of Mercia and Wessex united to form England.

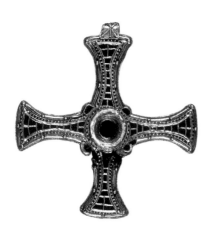

above **Gold and garnet cross found in the coffin of St Cuthbert (died 687). A similar pendant cross was found in the hoard** *below*.

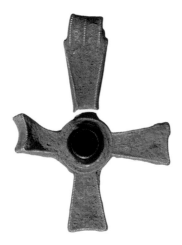

top right **Pendant with three bird's heads from Faversham, Kent. Late 6th–7th century.**

and Suffolk, Wessex in the south-west and the kingdoms of Kent and Sussex in the south-east. The Anglo-Saxons were pagans, the names of some of their gods surviving in the days of the week: Tiws-day, Wodens-day and Frigs-day). Conversion to Christianity officially came with St Augustine's mission to Kent in 597, but Irish missionaries were already active in the north and there is likely to have been some surviving Roman Christianity. Penda was the last pagan king of Mercia, but he was well aware of Christianity through his ally Cadwallon.

Most of the people were peasants, tending the land and animals in the never-ending annual cycle. However, these people had access to jewellery, beads and weapons and were, perhaps, not impoverished. By the seventh century an aristocracy seems to have been rising; including the warriors whose weapons were found the Staffordshire Hoard. The most striking example of this aristocracy is the wonderful ship burial discovered at Sutton Hoo in Suffolk in 1939. This contained all of the trappings of seventh-century aristocratic life and fills out the strongly martial picture given by the Staffordshire Hoard. One of the most exciting aspects of the new find is that we can use it to look again at Sutton Hoo and learn more.

While often seen as merely an interlude between Roman Britain and medieval England, the Anglo-Saxon period was a time of great change. It lasted around 650 years, longer than both of the other periods. Starting as a tribal society, Anglo-Saxon England ended as single unified state, with towns, trade and an impressively efficient system of taxation. Most importantly, it laid the foundations of the English language, which has spread all over the world.

opposite **Opening of the *Historia Ecclesiastica* from the 'Tiberius' Bede. The decoration on this delightful 9th-century manuscript follows a tradition seen on objects in the hoard.**

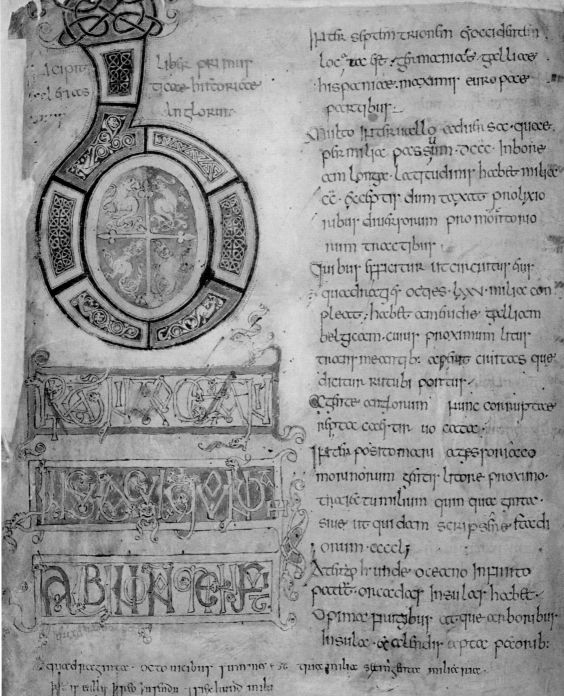

The Sutton Hoo ship burial

The Sutton Hoo ship burial was excavated from near Woodbridge, Suffolk, in the spring and summer of 1939, just before the outbreak of the Second World War. Its remarkable finds signalled a radical change in attitude towards early Anglo-Saxon society, which until then had been thought culturally inferior to life during the Roman period.

Deeply buried beneath a large mound lay the ghost of an oak ship, twenty-seven metres long. At its centre was a ruined burial chamber the size of a small room, built with a pitched roof and hung with textiles. In it we assume that a dead man lay surrounded by his possessions, although no body was found. He was buried with his weapons, his armour, wealth in the form of gold coins and gold and garnet fittings, silver vessels and silver-mounted drinking horns and cups, symbols of power and authority, and clothes, piled in heaps, ranging from fine linen overshirts to shaggy woollen cloaks and caps trimmed with fur. The burial also contained a leather purse with a jewelled lid. This had held a group of thirty-seven Merovingian gold *tremisses*, three coin-sized blanks and two ingots. While the finds from this burial reflect the status of the dead man, they are also a reminder of the master craftsmen, including swordsmiths and gold-smiths, who had made these remarkable objects.

While the Sutton Hoo find is the most elaborate example, three-rivet buckles are the most common gold objects to be found in 7th-century men's graves. Their absence in the Staffordshire Hoard is striking.

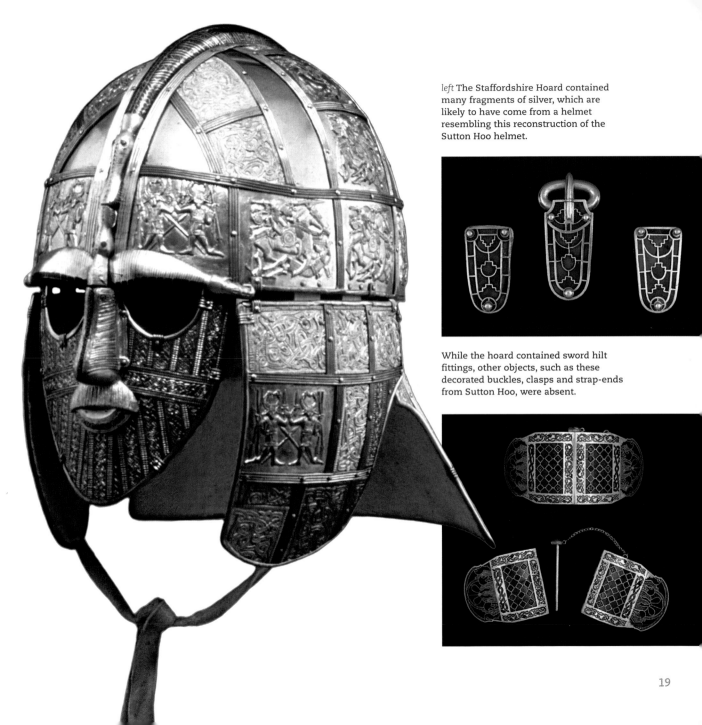

left The Staffordshire Hoard contained many fragments of silver, which are likely to have come from a helmet resembling this reconstruction of the Sutton Hoo helmet.

While the hoard contained sword hilt fittings, other objects, such as these decorated buckles, clasps and strap-ends from Sutton Hoo, were absent.

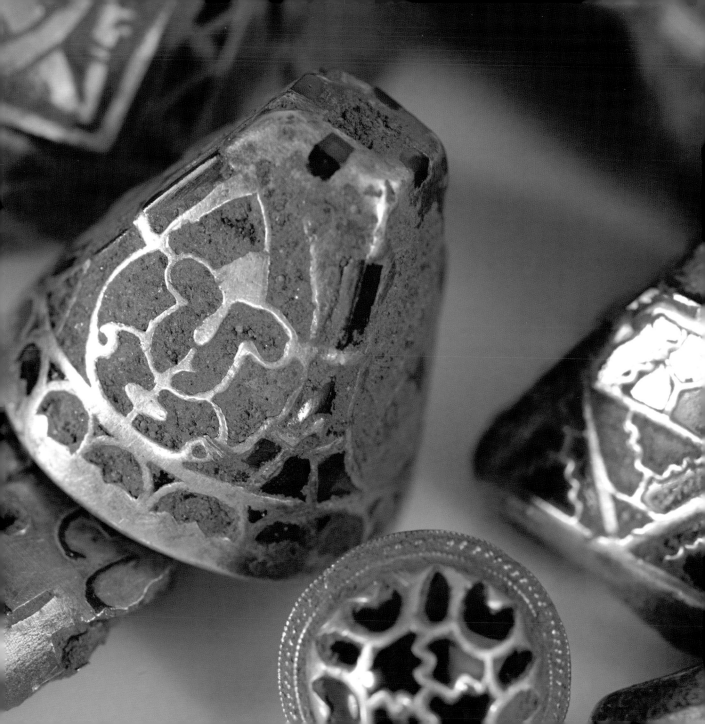

helmets

PARTS from at least one highly decorated helmet are likely to be among the finds, although piecing these together will undoubtedly take considerable time and effort. One of the most conspicuous fragments is what appears to be a magnificent cheek-piece, ornamented with a frieze of running, interlaced animals. Interestingly, this piece has a relatively low gold content. This may be the result of it being specially alloyed to make the metal harder and so better to withstand blows.

A powerful animal's head is also possibly the crest of a helmet (see pp.26–7). Large numbers of fragments of C-sectioned silver edging and reeded strips could also be helmet fittings. Similar fragments, made from base metal, formed part of the Sutton Hoo helmet (see p.19).

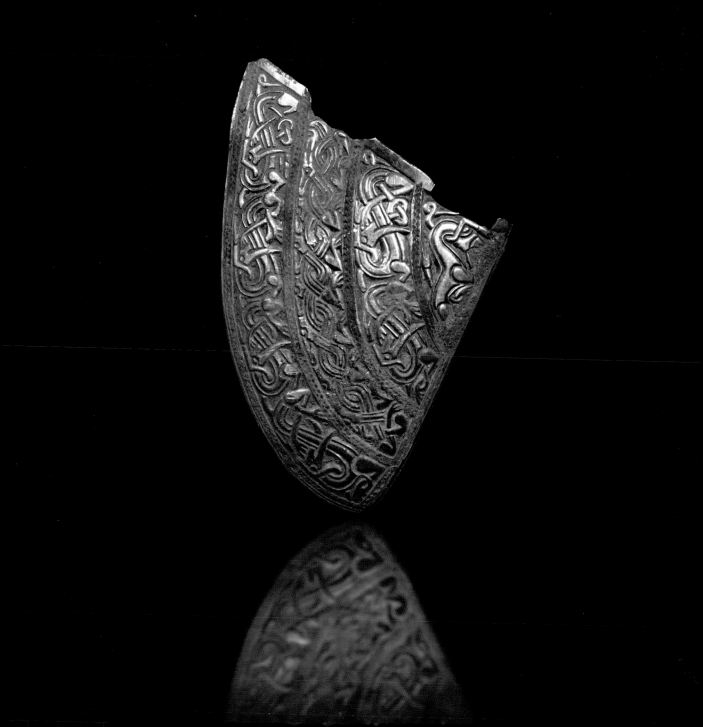

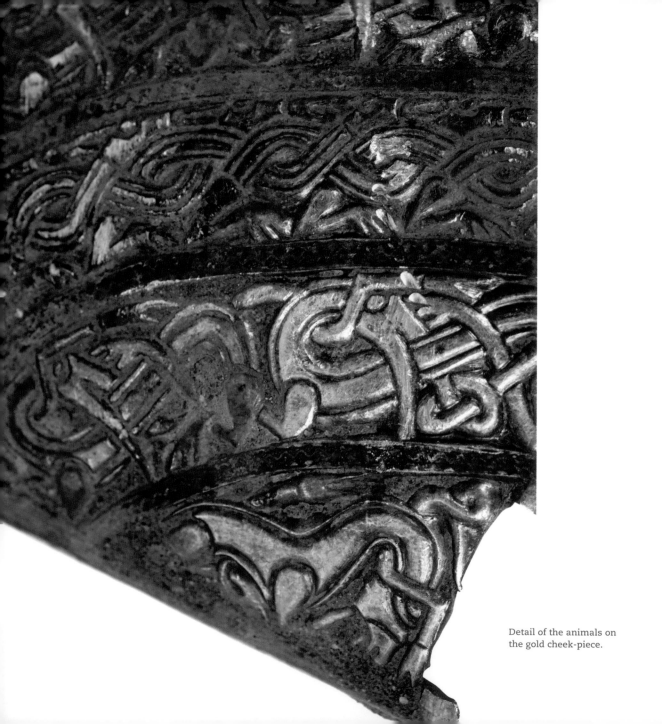

Detail of the animals on
the gold cheek-piece.

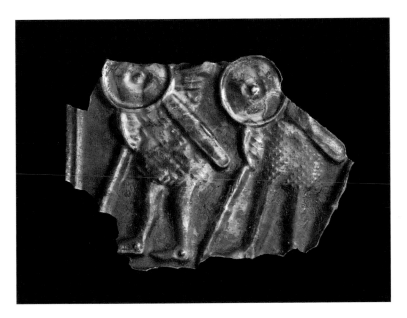

A fragment of silver plate, probably from a helmet, showing two warriors holding round shields, spears and swords.

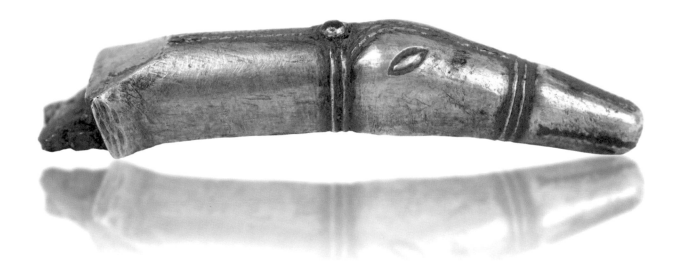

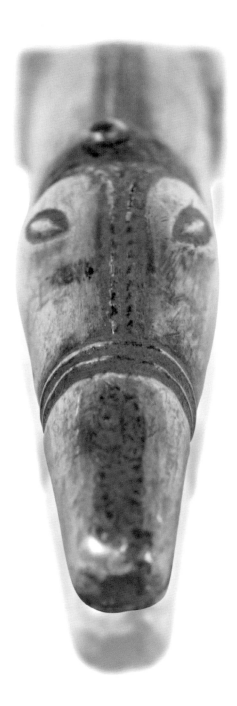

Helmet fitting with a terminal in the form of an animal.

sword hilt fittings

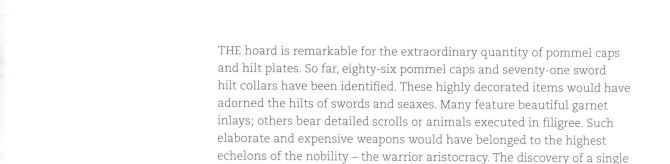

THE hoard is remarkable for the extraordinary quantity of pommel caps and hilt plates. So far, eighty-six pommel caps and seventy-one sword hilt collars have been identified. These highly decorated items would have adorned the hilts of swords and seaxes. Many feature beautiful garnet inlays; others bear detailed scrolls or animals executed in filigree. Such elaborate and expensive weapons would have belonged to the highest echelons of the nobility – the warrior aristocracy. The discovery of a single sword fitting is a notable event; to find so many together is unprecedented.

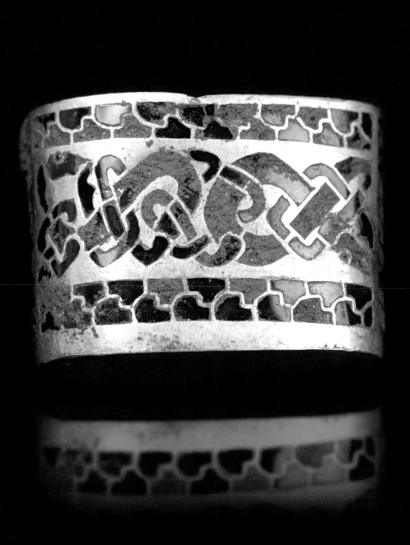

FOR ONE WARRIOR STRIPPED THE OTHER,
LOOTED ONGENTHEOW'S IRON MAIL-COAT,
HIS HARD SWORD-HILT, HIS HELMET TOO

BEOWULF

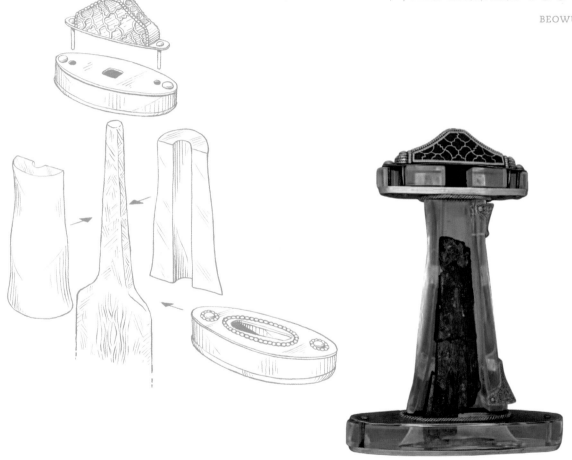

The original fittings of the Sutton Hoo sword on
a modern mount show what a sword hilt would
have looked like.

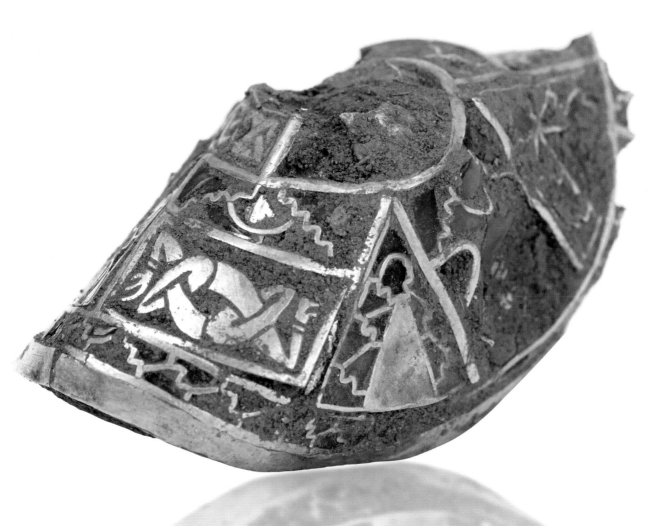

Though of consummate workmanship, the function of this object is not yet known. Finds like this present both a challenge and a great opportunity. They take us into the unknown.

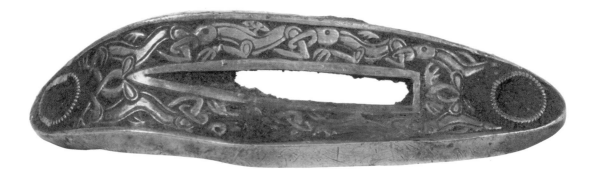

Gold hilt plate, decorated with fine Style II
animals. The hole through the centre shows
that the blade was single edged.

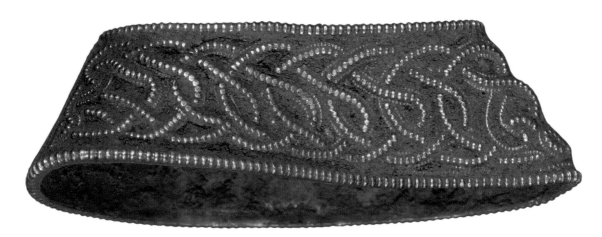

Gold sword hilt collar with geometric interlace
on one side, zoomorphic interlace on the other.

Sword pommel cap set with finely cut garnets. The wire extending from the side is part of one of the rivets that secured the cap in place.

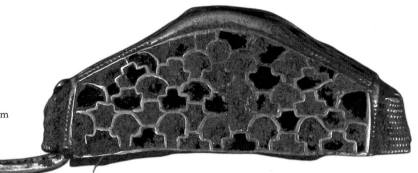

Top view of the pommel cap illustrated above.

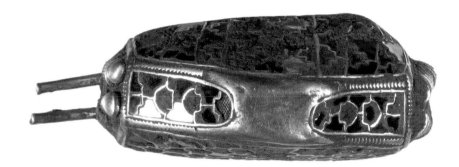

Gold sword pommel decorated with filigree on both faces.

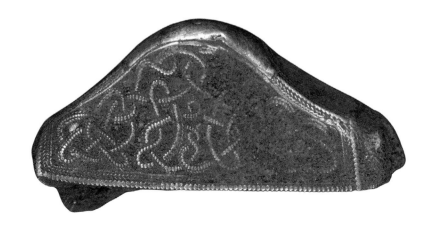

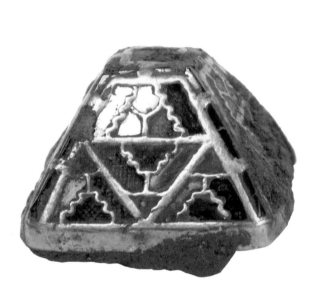
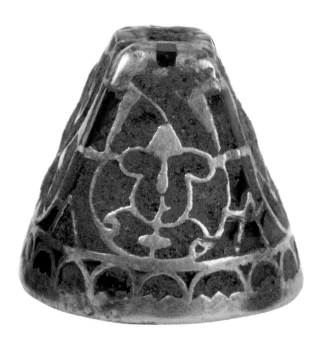

Garnet-set sword pyramids. These may have been attached to the straps that held the sword in its scabbard. If the image is inverted it can be seen that the taller pyramid is decorated with two facing birds, probably eagles.

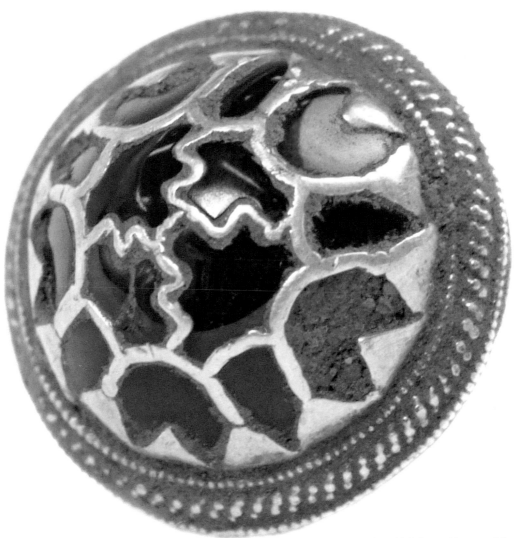

Button-like gold fittings with garnet inlay very similar to this were found near the hilt of the Sutton Hoo sword and must have been used to hold it in place.

the folded cross

THE only items that are clearly not war-gear are four, or possibly five, crosses (see also pp. 16 and 38–9). The largest may have been an altar or processional cross. Other than the loss of the settings used to decorate it (some of which are present but detached), it is intact. However, it has been folded, possibly to make it fit into a small space prior to burial. This apparent lack of respect shown to this Christian symbol may point to the hoard being buried by pagans, but Christians were also quite capable of despoiling each other's shrines.

Right **The folded cross and** *above* **an artist's reconstruction of the cross in its original state.**

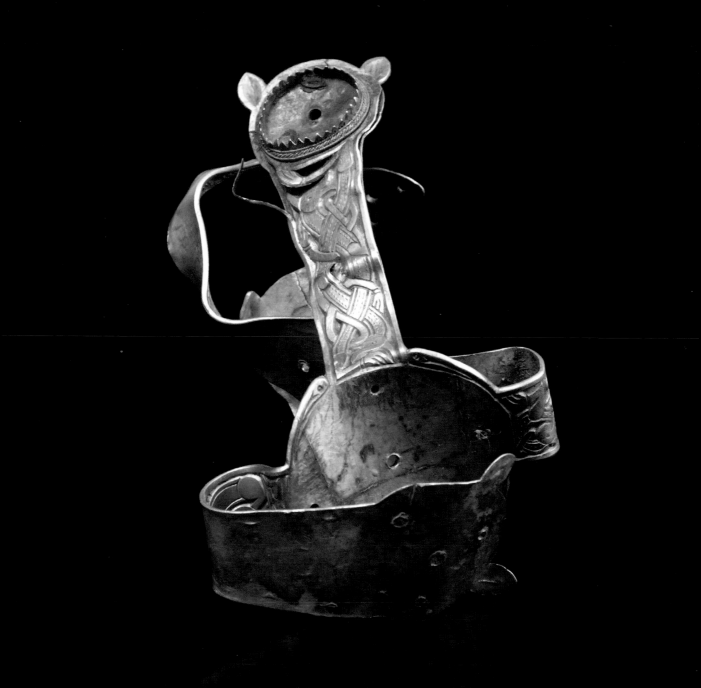

the biblical inscription

A STRIP of gold bearing an inscription from the Vulgate version of the Latin Bible is one of the most significant and controversial finds (see also p.2 for a view of the other side). It is thought to come from another cross. Michelle Brown, Professor of Medieval Manuscript Studies, has suggested the style of lettering dates from the seventh or early eighth centuries. The lettering on the outside of the strip is carefully executed, with the letters of a uniform size, well spaced and many containing large decorative triangular serifs. The text was incised and the letters then filled with niello.

The suitably warlike inscription, mis-spelt in places, is from the Book of Numbers 10:35 or Psalm 68:1 and reads:

Surge domine et disepentur [dissipentur] inimici tui et fugent [fugiant] qui oderunt te a facie tua

RISE UP, O LORD, AND MAY THY ENEMIES
BE DISPERSED AND THOSE WHO HATE THEE
BE DRIVEN FROM THY FACE

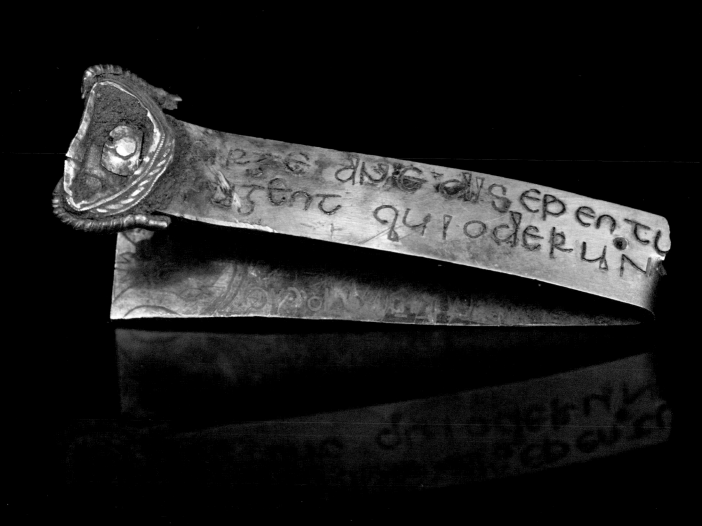

Again the function of this object is not known. Made of gold, it depicts two Style II eagles holding, between them in their talons, a fish. This is an object of barbaric splendour.

the eagle mount

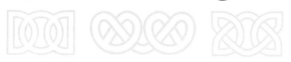

METAL birds and fish were often used as emblems on the faces of Anglo-Saxon shields and it is possible that this splendid object may, too, have come from a shield. The two birds resemble an eagle mounted on the face of the Sutton Hoo shield. A strange silver looped ring found with the hoard is also comparable to a fitting from the Sutton Hoo shield.

Other objects from the hoard

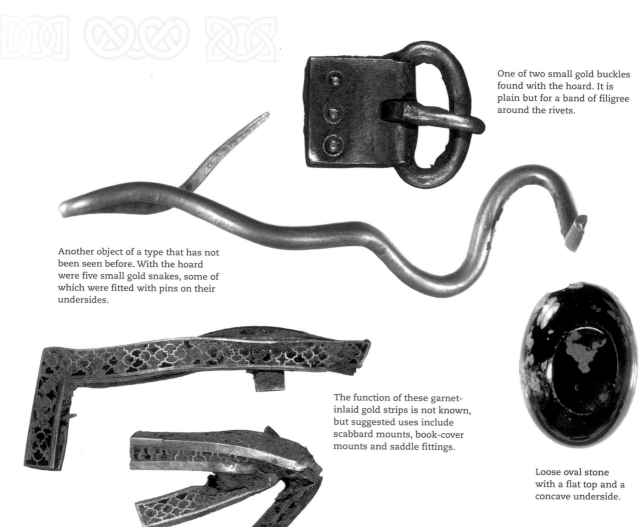

One of two small gold buckles found with the hoard. It is plain but for a band of filigree around the rivets.

Another object of a type that has not been seen before. With the hoard were five small gold snakes, some of which were fitted with pins on their undersides.

The function of these garnet-inlaid gold strips is not known, but suggested uses include scabbard mounts, book-cover mounts and saddle fittings.

Loose oval stone with a flat top and a concave underside.

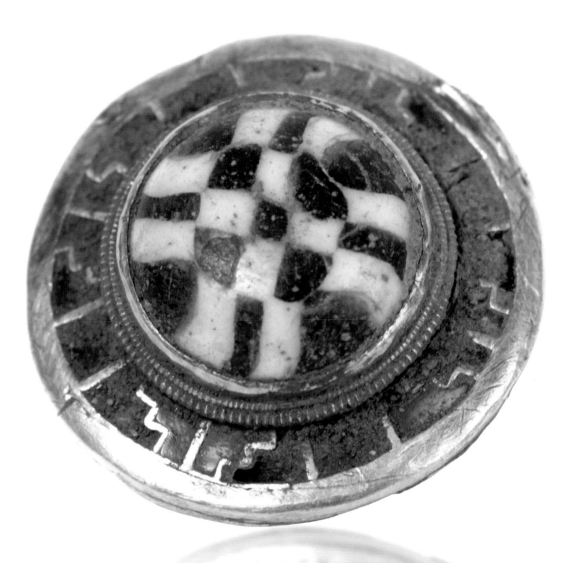

A glass gem within a gold and garnet setting. This object is interesting as glass work of this sort is likely to have been a product of the Celtic west.

Summary of Staffordshire hoard

Description	Gold	Silver	Base metal	Composite metals	Stone and glass	Uncertain	Total
Appliqué	1						1
Bead					1		1
Boss	6	1					7
Brooch		1					1
Buckle and plate	2						2
Button	1						1
Cross	5						5
Dome		1					1
Edging	11	69	6	1			87
Fish	1						1
Fitting	35	11	3	4			53
Foil	16						16
Fragment	79	177	29	19		7	311
Garnet					26		26
Glass gem					1		1
Glass fragment					4		4
Mount	15	4					19
Panel	3						3
Pin	2	5					7
Plate	58	13	1	1	1		74
Ring	12	1					13
Rivet	27	29	5	4			57
Setting	2				1		3
Sheet metal	36	233	12	3		2	286
Slag						2	2
Snake	5						5
Soil blocks						33	33
Spillage			1				1
Stone					1		1
Strip	94	102	5	1		1	203
Stud	9	3	1				13
Sword hilt plate or fitting	178	29	8	1		1	217
Sword pommel	69	10	5	2			86
Sword pyramid	8	1		1			10
Sword scabbard loop	1						1
Wire	34	13	1			1	49
Unidentified	2	4	1	2	1	8	18
Total	**712**	**707**	**73**	**10**	**36**	**47**	**1585**

Note: Work is still continuing on this hoard and all these figures are provisional.

The Treasure Act and Portable Antiquities Scheme

METAL detecting is legal in England and Wales providing you have the permission of the landowner and avoid protected sites. All detectorists are strongly urged to follow the Code of Practice for Responsible Metal Detecting in England and Wales, which includes avoiding protected sites and reporting all archaeological finds to the Portable Antiquities Scheme (PAS). Although it is voluntary to report most archaeological finds, if the find is Treasure, such as the Staffordshire Hoard, there is a legal requirement to report it.

Under the Treasure Act 1996 the following finds are defined as Treasure provided they were found after 24 September 1997: (a) objects other than coins at least 300 years old with a minimum precious metal content of 10%; (b) all groups of coins from the same find at least 300 years old (if the coins have a precious metal content of less than 10%, then the hoard must consist of at least 10 coins); (c) objects found in association with Treasure; and, from 1 January 2003, (d) groups of prehistoric base-metal objects from the same find.

Finders are legally required to report all finds of potential Treasure and if the find is declared Treasure it is offered to a national or local museum to acquire for public benefit. If this happens a reward is paid, which is normally shared equally between the finder and landowner. The reward is fixed at the full market value of the find, determined by the Secretary of State on the advice of an independent panel of experts – the Treasure Valuation Committee.

The PAS encourages the voluntary reporting of all archaeological finds. The Scheme also has an important educational role, enabling children and adults to learn about archaeology and bring the past to life. It consists of a network of Finds Liaison Officers, based in museums and archaeology services around England and Wales, as well as six National Finds Advisers. In 2008, the Scheme recorded 56,065 finds, which offer an important and irreplaceable way of understanding our past. More information can be found at www.finds.org.uk.

The next steps

GIVEN the intense interest in the hoard in the West Midlands, the British Museum stepped back from attempting to acquire it and supported a joint bid from Birmingham Museums and Art Gallery and the Potteries Museum & Art Gallery, Stoke-on-Trent, in partnership with Lichfield District, Staffordshire County and Tamworth Borough Councils.

Once the find had been declared Treasure, the next step was for it to be valued by the Treasure Valuation Committee. The Committee's remit is to value finds at a fair market value, which is then divided equally between the finder and the owner of the land where the find was made. The Committee commissioned valuations from four members of its panel of valuers, all leading experts in auction houses and the antiquities market. It met on 25 November 2009 to consider the hoard and recommended a valuation of £3,280,000. This was immediately accepted by all parties.

Birmingham and Stoke-on-Trent museums are now engaged in a fundraising campaign, led by the Art Fund, to keep the hoard in the West Midlands. It is hoped to raise the money within the four month target set down in the Treasure Act Code of Practice. The museums' fundraising campaign needs to be for a substantially larger sum than the valuation placed on the hoard by the Treasure Valuation Committee, since funding is also required to conserve and research

the hoard, to display it and to ensure that it can be seen as widely as possible in the West Midlands.

The British Museum, the Portable Antiquities Scheme, Birmingham and Stoke museums, Staffordshire County Council and English Heritage are working together on a continued programme of research into this find and its context. The first priority is to conserve the objects as no conservation could take place until the valuation had been agreed. The British Museum and Birmingham and Stoke museums are planning a joint programme of conservation and scientific research. Work is also planned to examine the context of the findspot under the leadership of Staffordshire County Council and English Heritage, with input from Birmingham Archaeology.

The Portable Antiquities Scheme has already been able to provide the services of Dr Kevin Leahy, National Finds Adviser and an expert on Anglo-Saxon artefacts, who constructed the initial handlist of the hoard in a period of less than eleven weeks from its initial discovery. He will continue his study in conjunction with a team of other experts, advising on particular aspects of the finds and their context and historical background. The provisional handlist of the hoard is already published online (www.staffordshirehoard.org.uk) and this will be updated and expanded as the work progresses.

Further reading

Arnold, C.J., *An Archaeology of the Early Anglo-Saxon Kingdoms*, Routledge (2nd edn 1997)

Blair, J., *The Anglo-Saxon Age: A Very Short Introduction*, Oxford Paperbacks (2000)

Evans, A.C., *The Sutton Hoo Ship Burial*, British Museum Press (1994, repr. 2008)

Heaney, S (trans.), *Beowulf: A New Translation*, Faber & Faber (1999, repr. 2000)

Leahy, K., *Anglo-Saxon Crafts*, Tempus Publishing (2003)

Marzinzik, Sonja, *The Sutton Hoo Helmet*, British Museum Press (2007)

Stenton, F.M., *Anglo-Saxon England*, Oxford University Press (3rd edn 2001)

Picture credits